Smile And The World Smiles With You

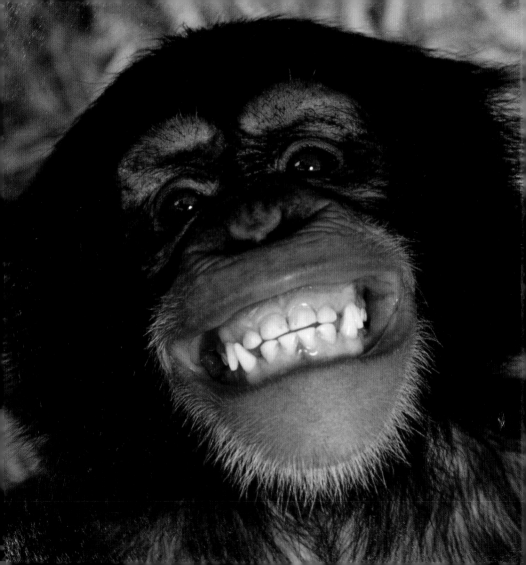

Smile And The World Smiles With You

David Baird

MQP

PUBLISHED BY MQ PUBLICATIONS LIMITED
12 THE IVORIES, 6–8 NORTHAMPTON STREET
LONDON N1 2HY
TEL: +44 (0) 20 7359 2244
FAX: +44 (0) 20 7359 1616

EMAIL: MAIL@MQPUBLICATIONS.COM
WEBSITE: WWW.MQPUBLICATIONS.COM

COPYRIGHT © 2004 MQ PUBLICATIONS LIMITED
TEXT COMPILATION © 2004 DAVID BAIRD
ARTWORK © JANET BOLTON

ISBN: 1-84072-611-3

10 9 8 7 6 5 4 3 2 1

PRINTED AND BOUND IN CHINA

Wear a smile and have friends; wear a scowl and have wrinkles. What do we live for if not to make the world less difficult for each other?

GEORGE ELIOT

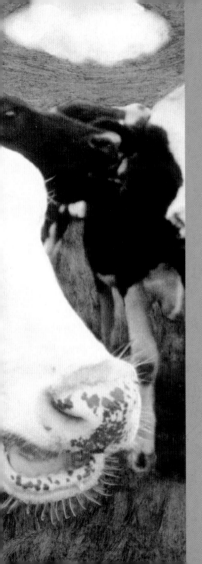

When fortune empties her chamber pot on your head, smile and say, "We are going to have a summer shower."

SIR JOHN A. MACDONALD

9

A Scout smiles and whistles under all circumstances.

ROBERT BADEN-POWELL

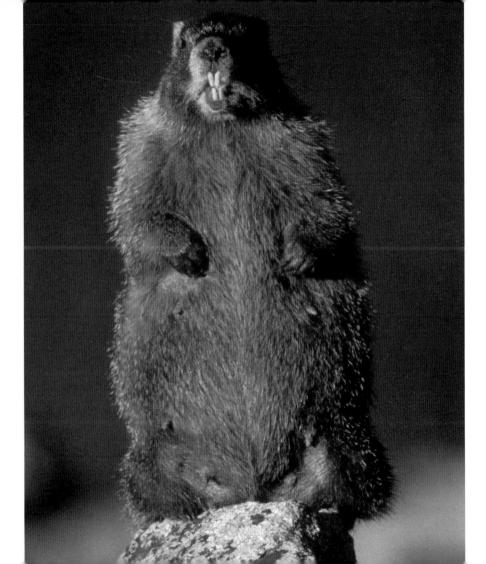

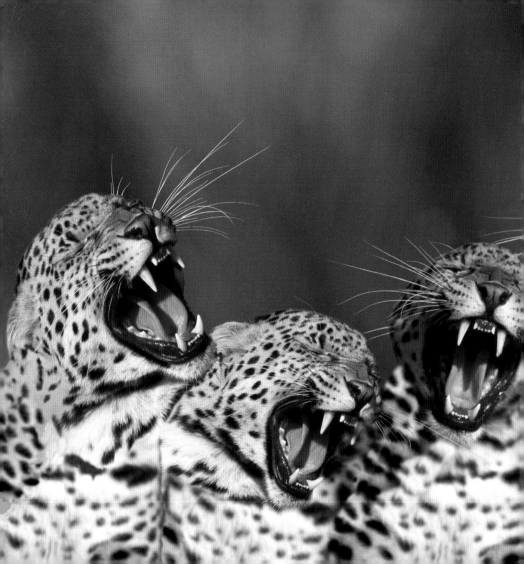

We are a nation that has always gone in for the loud laugh, the wow, the yak, the belly laugh, and the dozen other labels for the roll-'em-in-the-aisles gagerissimo.

JAMES THURBER

13

Youth smiles without any reason. It is one of its chiefest charms.

THOMAS GRAY

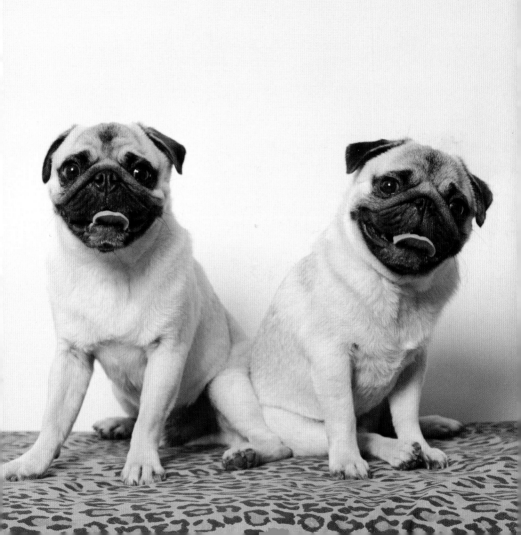

A poet writ a song of May
That checked his breath awhile;
He kept it for a summer day,
Then spake with half a smile:

"Oh, little song of purity,
Of mystic to-and-fro,
You are so much a part of me
I dare not let you go."

RICHARD BURTON

A smile is an inexpensive way to change your looks.

CHARLES GORDY

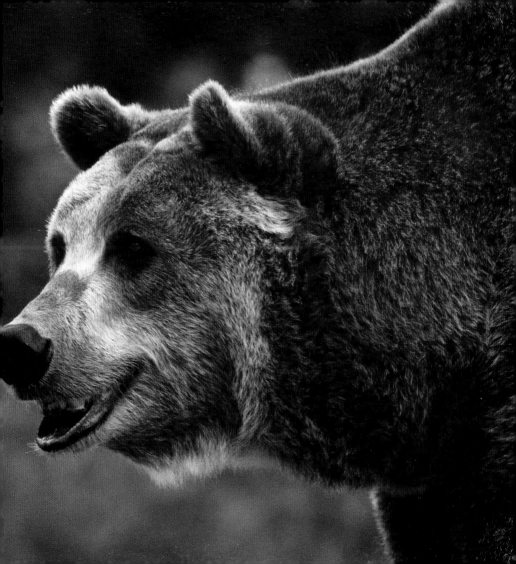

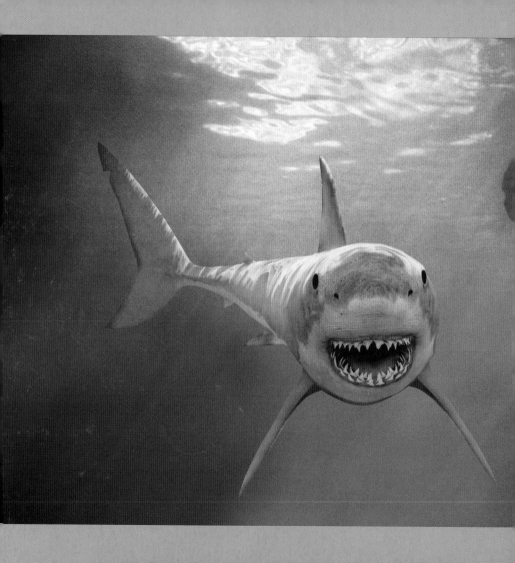

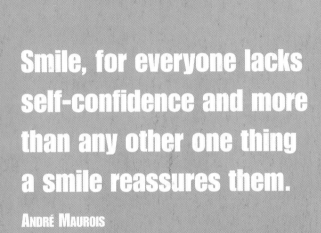

Smile, for everyone lacks
self-confidence and more
than any other one thing
a smile reassures them.

ANDRÉ MAUROIS

We sometimes laugh
from ear to ear, but it
would be impossible for
a smile to be wider than
the distance between
our eyes.

MALCOLM DE CHAZAL

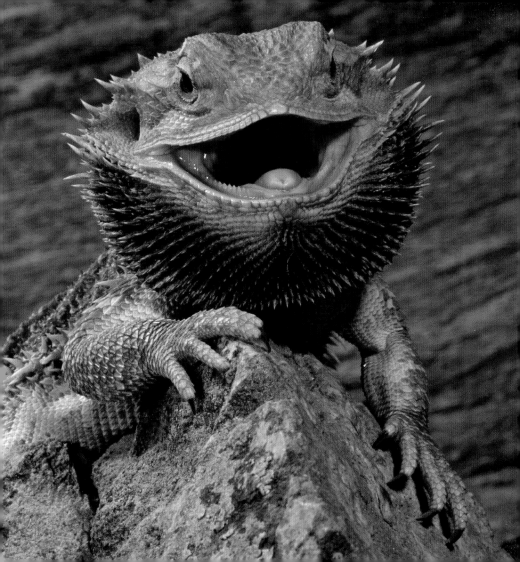

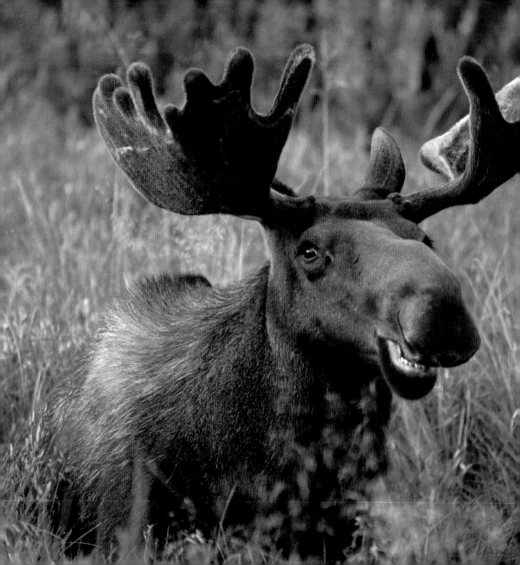

Smile and the world smiles with you, snore and you sleep alone.

ANONYMOUS

Something of a person's character may be observed by how they smile. Some never smile, they only grin.

CHRISTIAN NEVELL BOVEE

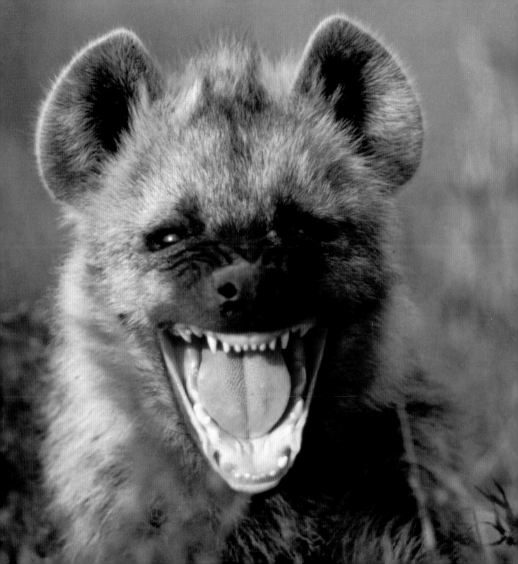

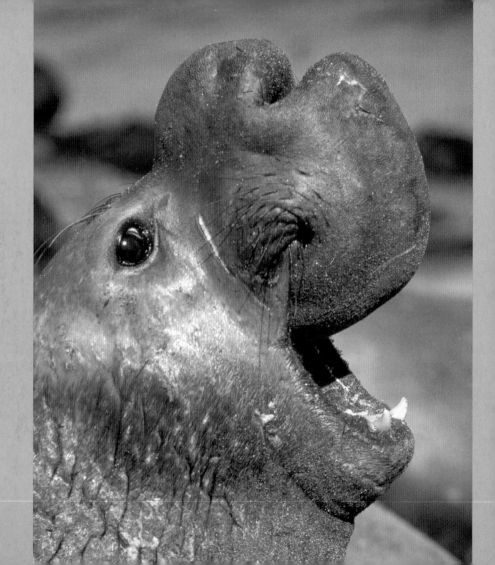

Ah, Hope! what would life be, stripped of thy encouraging smiles, that teach us to look behind the dark clouds of today, for the golden beams that are to gild the morrow.

SUSANNA MOODIE

Some people grin and bear it; others smile and do it.

ANONYMOUS

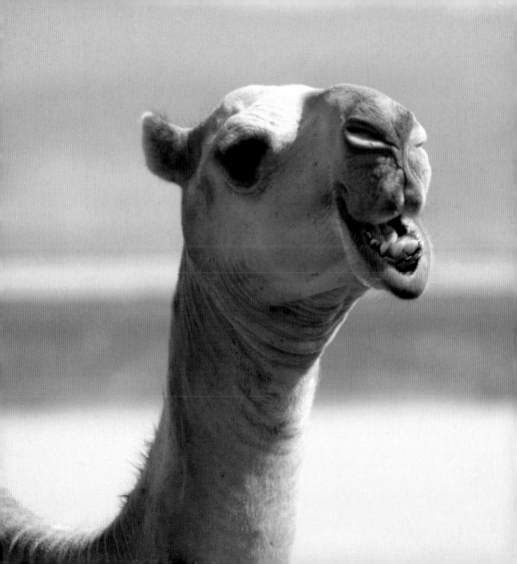

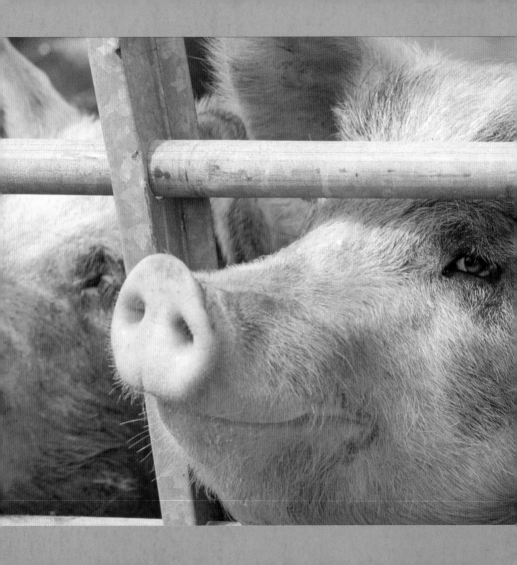

Smile first thing in the morning. Get it over with.

W. C. FIELDS

A woman has two smiles that an angel might envy—the smile that accepts a lover before words are uttered, and the smile that lights on the first born babe, and assures it of a mother's love.

THOMAS C. HALIBURTON

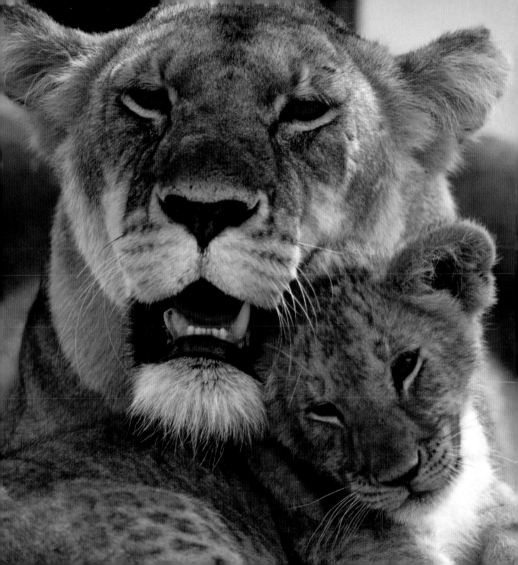

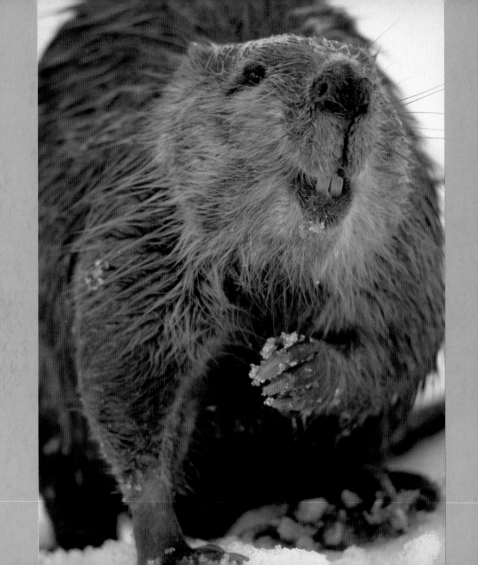

If we do meet again,
 we'll smile indeed;
If not, 'tis true this parting
 was well made.

WILLIAM SHAKESPEARE

Let no one ever come to you without leaving better and happier. Be the living expression of God's kindness: kindness in your face, kindness in your eyes, kindness in your smile.

MOTHER TERESA

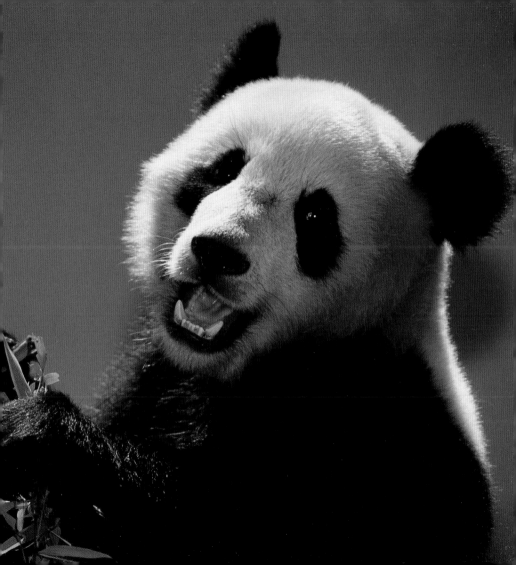

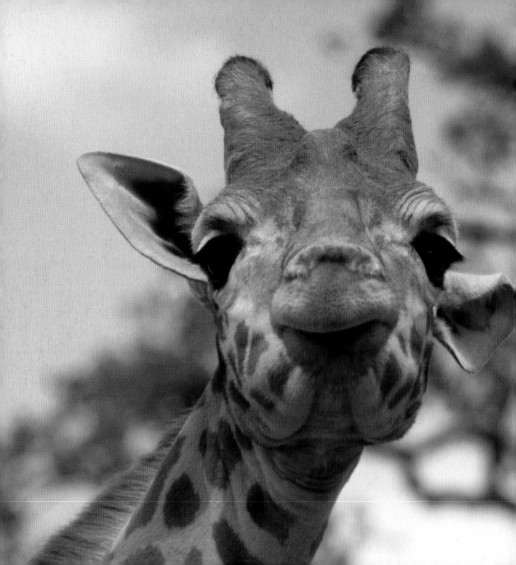

Every man who is high up loves to think that he has done it all himself; and the wife smiles, and lets it go at that.

SIR JAMES M. BARRIE

All nature wears one universal grin.

HENRY FIELDING

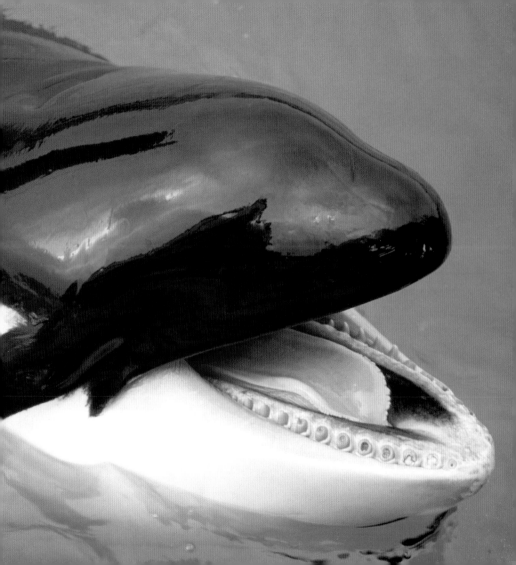

Wit is a weapon. Jokes are a masculine way of inflicting superiority. But humor is the pursuit of a gentle grin, usually in solitude.

FRANK MUIR

I have tried too in my time to be a philosopher; but, I don't know how, cheerfulness was always breaking in.

OLIVER EDWARDS

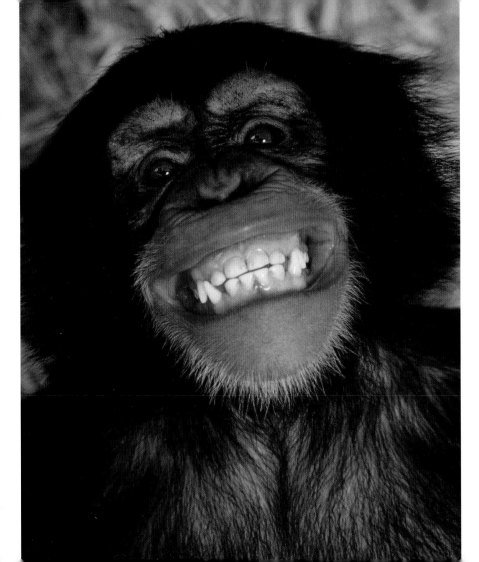

In came Mrs. Fezziwig, one vast substantial smile.

CHARLES DICKENS

If you have only one smile in you, give it to the people you love. Don't be surly at home, then go out in the street and start grinning "Good morning" at total strangers.

MAYA ANGELOU

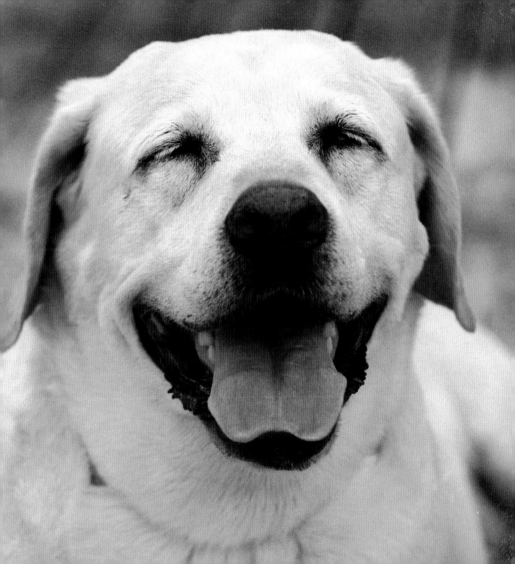

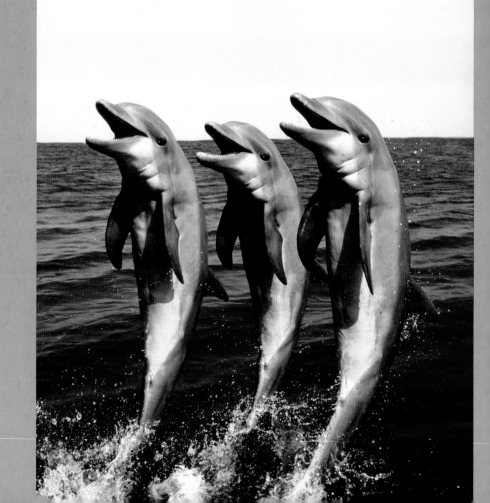

Pleasure is a necessary reciprocal. No one feels, who does not at the same time give it. To be pleased, one must please. What pleases you in others, will in general please them in you.

LORD CHESTERFIELD

A kind heart is a fountain of gladness, making everything in its vicinity freshen into smiles.

WASHINGTON IRVING

She is not fair to
 outward view,
As many maidens be;
Her loveliness
 I never knew,
Until she smiled on me:
Oh! then I saw her
 eye was bright,
A well of love, a
 spring of light.

HARTLEY COLERIDGE

Whence that three-cornered smile of bliss? Three angels gave me at once a kiss.

GEORGE MACDONALD

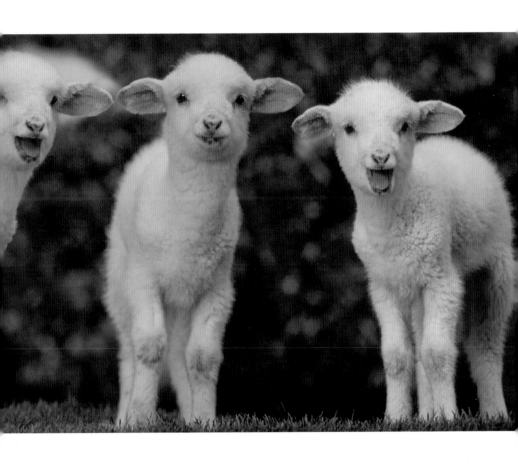

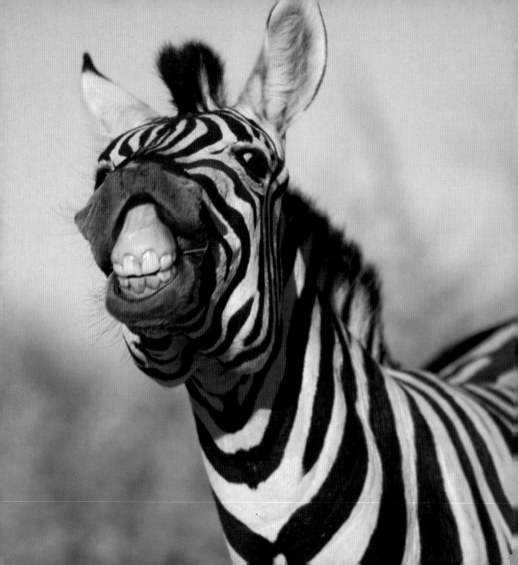

No matter how grouchy you're feeling,
You'll find the smile more or less healing.
It grows in a wreath
All around the front teeth—
Thus preserving the face from congealing.

ANTHONY EUWER

'Tis easy enough to be pleasant,
When life flows along like a song;
But the man worth while
 is the one who will smile
When everything goes dead wrong.

ELLA WHEELER WILCOX

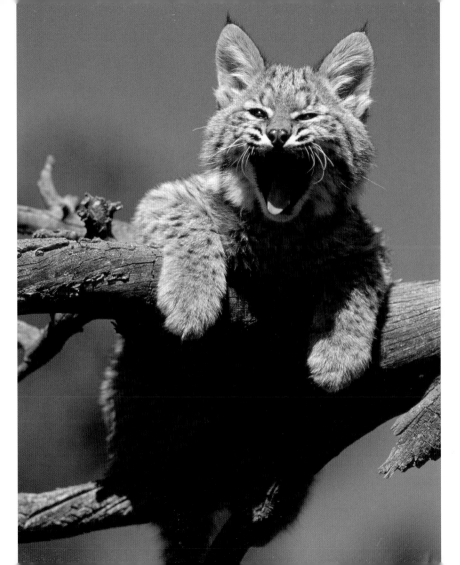

Smile and others will smile back. Smile to show how transparent, how candid you are. Smile if you have nothing to say.

JEAN BAUDRILLARD

A smile is a curve that sets everything straight.

PHYLLIS DILLER

Emerging slow from
 Academus' grove
In heavenly majesty
 she seemed to move.
Stern was her forehead,
 but a smile serene
'Softened the terrors
 of her awful mien.'

WILLIAM WORDSWORTH

Wrinkles should merely indicate where smiles have been.

MARK TWAIN

True humor springs not more from the head than from the heart. It is not contempt; its essence is love. It issues not in laughter, but in still smiles, which lie far deeper.

THOMAS CARLYLE

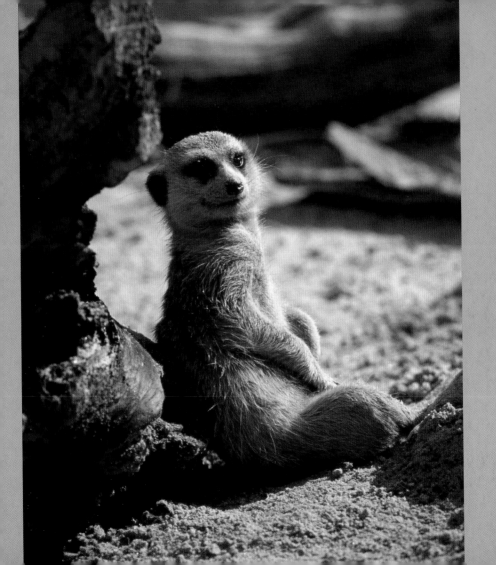

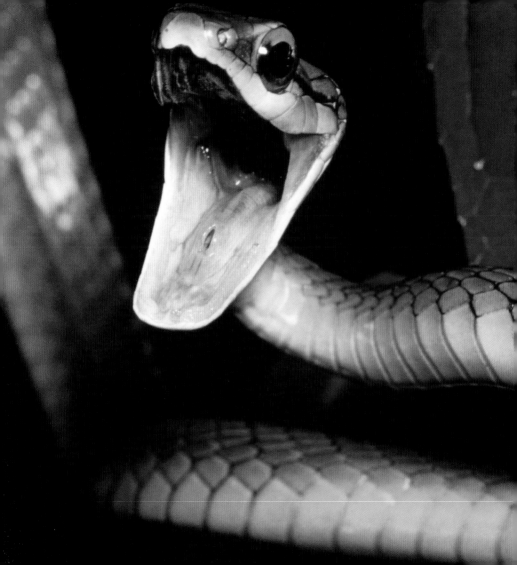

Colors are the smiles of nature.

LEIGH HUNT

It is almost impossible to smile on the outside without feeling better on the inside.

ANONYMOUS

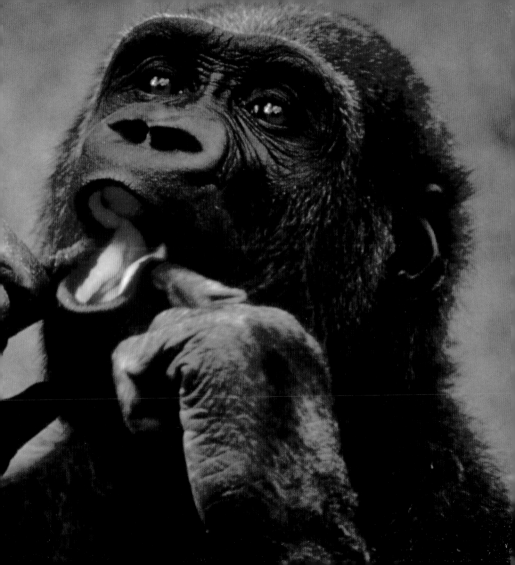

...as they pass they give me a little smile, and it seems as if everything was lighted up for me by a ray of bright sunlight.

HONORÉ DE BALZAC

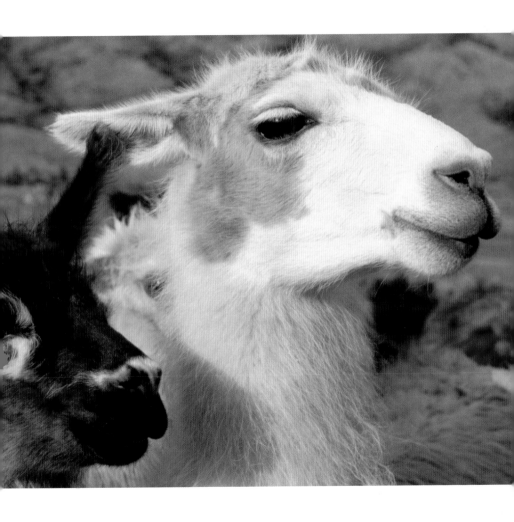

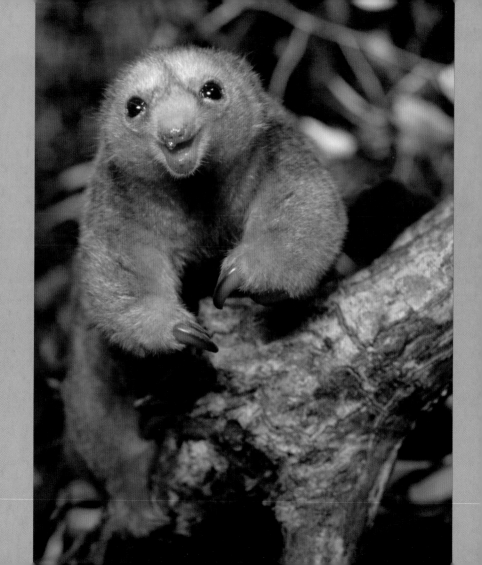

I smile at the suggestions of my heart, and obey its dictates.

JOHANN WOLFGANG VON GOETHE

Keep smiling— it makes people wonder what you've been up to.

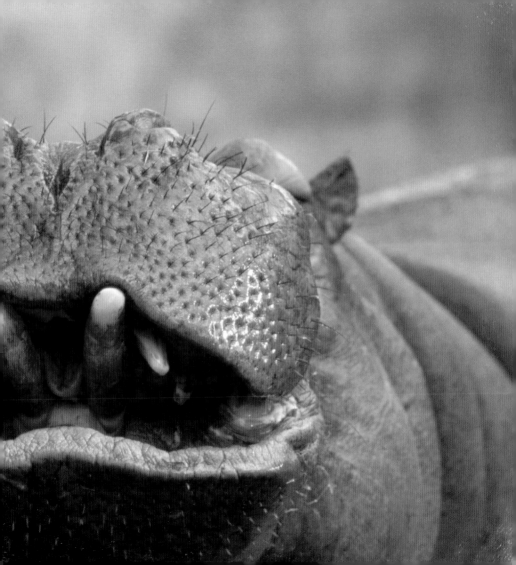

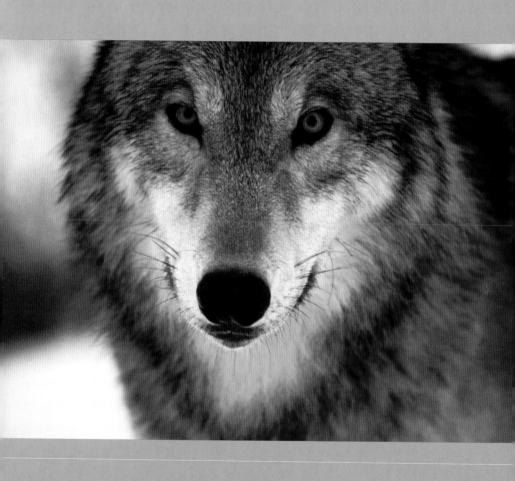

Oh! had he but thy cheerful smiles,
Limbs stout as thine, and lips as gay,
Thy looks, thy cunning, and thy wiles,
And countenance like a summer's day,
They would have hopes of him.

WILLIAM WORDSWORTH

There are many kinds of smiles, each having a distinct character. Some announce goodness and sweetness, others betray sarcasm, bitterness, and pride; some soften the countenance by their languishing tenderness, others brighten by their spiritual vivacity.

JOHANN KASPAR LAVATER

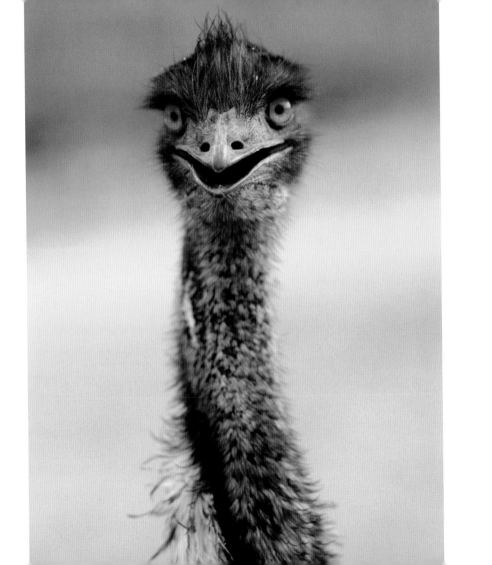

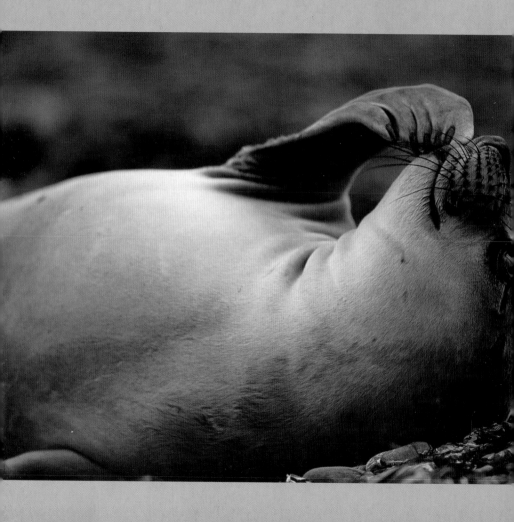

I live for those who love me,
Whose hearts are kind and true;
For the Heaven that smiles above me,
And awaits my spirit too.

GEORGE LINNAEUS BANKS

The world always looks brighter from behind a smile.

ANONYMOUS

Laughter is day, and sobriety is night; a smile is the twilight that hovers gently between both, more bewitching than either.

HENRY WARD BEECHER

The man who can smile when things go wrong has thought of someone else he can blame it on.

Robert Bloch

Photo Credits

Text Credits